T0079842

HOW
TO
LIVE
IN
A
FLAT

A Vision of Things to Come —
A Roof Idyll on Stratosphere Mansions

HOW TO LIVE
IN A FLAT

By

HEATH ROBINSON
and
K.R.G. BROWNE

This edition first published in 2015 by the
Bodleian Library
Broad Street
Oxford OX1 3BG

www.bodleianshop.co.uk

ISBN: 978 1 85124 435 5

First published in 1939 by Hutchinson & Co. Ltd.

Cover design by Dot Little at the Bodleian Library.
Designed and typeset by Roderick Teasdale
in 11.5pt on 11.5pt Tw Cen MT Light
Printed and bound on 90gsm munken cream by
TJ International Ltd., Padstow, Cornwall

British Library Catalogue in Publishing Data
A CIP record of this publication is available from the British Library

CONTENTS

DEDICATION

TO ANY HOUSE AND/OR ESTATE AGENT, AUCTIONEER, SURVEYOR AND VALUER

Dear Sir:

But for you, this book might never have seen the light. Of what avail to prate of flats, if you are not at hand to negotiate the let? We want the best homes; you have them. It is your grim task to reconcile those two irreconcilables—the landlord (to whom all tenants are destructive carpers) and the tenant (to whom all landlords are rapacious skinflints). That landlords are so seldom torn apart by maddened tenants, and tenants so seldom hamstrung by infuriated landlords, is largely due to the skill with which you contrive that hardly ever the twain shall meet.

Scarcely less admirable than your gift for diplomacy is your unquenchable optimism. Viewing the world through your rose-tinted glasses, you see every house as a desirable res., every flat as a unique opp., every seaside villa as but a stone's-throw from the beach. This lends to your conversation a buoyancy and charm which—though captious house-hunters have been known occasionally to differ from you—is most refreshing in this gloom-ridden age.

DEDICATION

Your versatility, too, commands our deep respect. Now agenting a house, now dittoing an estate, now auctioneering this, surveying that or valuing the other, you must be as fully occupied as a cat in an aviary.

As Wordsworth might have said of you, if Longfellow had not more or less forestalled him:

"Letting, surveying, valuing, onward through life he goes. Each morning sees some lease drawn up, each evening sees one close. . ."

It is in sincere admiration, therefore, of your many qualities, and in appreciation of the vital part you play in the daily—or rather quarterly—life of the nation, that this book is dedicated to you. No hard feelings, we hope?

Proving That There is Room to Swing a Cat

Early Flats

Nothing New Under The Sun

THE EVOLUTION OF THE FLAT

History does not, so far as I know, record the name of the person who invented the Home—probably because he was devoured by a wry-necked megatherium before he could be interviewed by the daily Press, which was not then in existence. It seems certain, however, that the first and original Home was merely a hole in a cliff, wholly lacking in modern conveniences and furnished chiefly with the skins of such animals as could be persuaded to part with them.

That, of course, was a long time ago—away back in the days when men did their wooing with a bludgeon and the bat-eared pleiosaurus nested undisturbed in the boskage of St. John's Wood. It was not until considerably later that the art of dwelling was

revolutionised by the discovery that pieces of wood could be nailed together in the shape of a large box and inhabited by several persons. From that moment caves began to decline in popularity among the intelligentsia; and when some unknown genius, fooling about in a clay-pit one mild spring afternoon, found that he had inadvertently invented bricks, the cave's little hour was definitely over. Its place in public favour was taken by the House; and people have been living in houses ever since, apart from an annual fortnight at Southend or Deauville and an occasional spell in gaol.

Of recent years, however, it has become increasingly apparent that the House, too, has had its day, and that the dwelling-place of the future is the Flat—so called because it usually is, and to distinguish it from the maisonette, which isn't. For this there are several reasons, mainly financial. What with rent, rates, stair-carpets, the depredations of mice, and the tendency of gardeners to bare their fangs if denied their lawful wage, a house of any kind costs a good deal to keep up. (That is especially true of those large country houses—colloquially known as "the stately homes of England"—where butlers are employed by the half-dozen and guests are provided with bicycles to enable them to reach the bathroom. But as the majority of these have now been converted into country clubs or dog-racing centres, they need not concern us at the moment.)

The Servant Problem has also done its bit, and a bit more, towards depopularizing houses. The most efficient housewife cannot run a large establishment without the help of minions; and nowadays minions—ay, and myrmidons to boot—are as scarce as second-hand coffins. Time was when vast herds of cooks, both

The Roof Garden

Romantic Possibilities in Modern Flats

plain and fancy, roamed the open spaces of Mayfair, when fully fledged butlers could be bagged by the dozen at any of their favourite drinking-pools, and when the most superior parlourmaids cost but a few guineas a brace.

But those happy days—alas!—are gone beyond recall. The parlourmaids have turned ash-blonde and migrated with shrill cries to Elstree, the cooks have married the butlers, and the butlers are living a life of ease on their accumulated tips. Today even 'tweenies are hopelessly shy on the wing, while housemaids—even of the ham-handed type so highly esteemed by the Potteries—are as hard to find as a new excuse for evasion of income-tax.

Hence the Flat. Reduced to its lowest terms (which, however, are seldom lower than £80 per annum), a flat is simply a portion of a house that has been converted but not entirely convinced. Since the primary purpose of flats is to enable at least five families to live where only one hung out before, thereby quintupling the landlord's income, they are apt to lack that spaciousness which characterizes the Grand Central Terminal, New York. From the keen cat-swinger's point of view this is regrettable, but it enables the little woman to run the home single-handed, with only the occasional help of a stout female in elastic-sided boots. And, anyway, dominoes is (or are) rapidly displacing cat-swinging as the favourite indoor pastime of the masses.

In the last few years large blocks of flats—usually resembling Utopian prisons or Armenian glue-factories—have sprung up all over the place, to the delight of some and the annoyance of many. These flats, though fitted with every up-to-date luxury—

such as intermittent hot water and a porter with real brass buttons—are generally quite small, and getting smaller all the time, apparently. Thus the incoming tenant who has been accustomed to living in houses is liable at first to feel slightly crowded, as might a fly which, having been born and raised in the Albert Hall, was abruptly transferred in the evening of its days to a medium-sized dog-kennel.

It is for the benefit of such novice flat-dwellers that this book has been devised, regardless of expense and with malice towards none. Once recovered from his initial bout of claustrophobia, the tenant of a modern flat—or of an ancient one, for that matter—should find it easy to readjust his life with the help of the hints hereinafter set forth. (The said hints can also be cut out, mounted on stiff parchment, and used as a novelty lamp-shade—if there is room in the flat for a lamp-shade.) There will be no more cat-swinging for him, of course, no more jolly games of Hide-and-Seek, and no more privacy—or only about as much as is enjoyed by a tinned sardine; but he will find that he can have a lot of quiet fun in one way and another.

Certain of the devices and expedients so brilliantly conceived and illustrated by Mr. Heath Robinson may have been thought of already by unusually imaginative flat-dwellers, though that seems hardly possible. But the majority, I feel confident, will bring joy to the heart of many a harassed flatwife—who differs from a housewife only in having less room to be harassed in—and cause her to bless the day on which she borrowed and expended the absurdly trivial sum demanded by the publishers for this unique and invaluable work.

14

A Flat Wedding

So much for that, and not one milreis more. It only remains to add that all the characters illustrated in this book are not merely fictitious, but downright impossible, and that no reference is intended to any existing person, block of flats, or goldfish.

Music Cum Comfort

Doing Without a Mantelshelf Need Not Worry You

ECONOMY OF SPACE

The first problem confronting the inexperienced flat-dweller, when he has signed the lease (which would probably be just as intelligible to him if it were written in Chinese) and coughed up the exorbitant sum demanded by the outgoing tenants for a dozen tarnished curtain-rings and three square yards of debilitated linoleum, is that of utilizing the floor-space of his new home to the best possible advantage. Here, on the one hand, is his flat, all swept and garnished and smelling so strongly of rancid wall-paper as to be almost uninhabitable; there, on the other, are himself and family. His task, then, is to adapt the latter to the former in a manner guaranteed to give satisfaction to all.

HOW TO LIVE IN A FLAT

This calls for considerable thought, floor-space—as we have previously made plain—being what the average flat has rather little of. Consequently, persons who have practically nothing to think with (and statistics show that these are approximately as numerous in the flat-dwelling business as in the film or any other industry) are inclined to fall down on the job, throw in their hands, and resign themselves to a life of perpetual discomfort.

Actually, as we are about to show, a little ingenuity is all that is needed here. The chief difference between the flat-dweller and the Earl of Totheringham (pronounced "Tum") is that the latter's home (Tum Towers, Ruts.) contains a separate room for every conceivable purpose and occasion, viz. a dining-room, a drawing-room, a morning-room, a smoking-room, umpty-three bedrooms, a still-room, sundry bath-rooms, a billiard-room, a ball-room, a gun-room, and even a little room at the back of the hall for keeping butlers in. (Probably there would be a coffee-room, too, if any of the Tums were really keen on coffee.) Thus any member of his Lordship's family who feels a sudden urge to dine, draw, spend a morning, smoke, go to bed, be still, wash his neck, play billiards, dance a fandango, shoot himself, or borrow a dicky can indulge his whim in privacy and solitude—or in a pair of swimming-trunks, for that matter.

Such exclusiveness and stand-offery is impossible, for obvious reasons, to the flat-dweller—or "Mr. Simpson", as a glance at the Telephone Directory will show that he is often called. Nevertheless, the exercise of a little care and carpentry will enable him to enjoy—though on a somewhat smaller scale—most of the amenities which make the lives of his belted better one long scream from start to finish.

Plan of a Four-roomed Flat Warmed by One Stove

Take, for example, the question of the Spare Bedroom. At Tum (spelt "Totheringham") Towers, I am informed by gossip-writers who have never stayed there, there are no fewer than fifteen of these, each capable of accommodating two full-sized adults (or one alderman), a brace of reasonably small kids, and a couple of Persian kittens. In the average flat, on the other hand, the spare room—if it exists at all, which isn't likely—is so small that its occupant can close the door, open the window, dust the wainscot, straighten the pictures, poke the fire, and (if he is that kind of occupant) write rude limericks on every wall without stirring from his bed.

True, he may never actually *wish* to do any of these things; but the knowledge that he *can* do so is liable (as Freud points out in his *Hard-Boiled Egos*, or *Short Cuts to the Loony-Bin*) to play havoc with his complexes and produce unsightly spots on his subconscious.

It is this fact that has inspired Mr. Heath Robinson, that big-hearted humanitarian, to invent the Dibedroom (Dībèdroom). This, as its name implies, is a combined dining-sleeping-room, fitted with an extra and movable wall which travels on small wheels (of wood, steel, or onyx, according to taste) and is propelled by the nearest man-power. To one side of this wall is affixed a highly collapsible bed, so designed that a mere child can operate it—though even an ordinary child would be well advised to let Daddy do it, in my opinion.

In the life of every flat-dweller there are moments when a visiting acquaintance—or, worse still, a visiting relation—glances at the clock, utters a low moan of dismay, and announces that he/she has missed his/her

The Spare Bedroom

last train/tram/omnibus back to Hampstead/Balham/Chorlton-cum-Hardy. In the ordinary way, this means a fevered search for extra blankets, a good deal of muffled cursing, the construction of an improbable bed-like arrangement on the hearthrug, and a sleepless night for the involuntary guest.

But for the fortunate owner of a Dibedroom this situation has no terrors. A few lusty tugs at the appropriate handle, a faint rumbling noise as the dining-room dwindles and the bedroom expands, a dull but not unpleasing thud as the bed drops into place—and the thing is done. Almost before the echoes of that low moan have died away, the visitor is tucked between the sheets and breathing sweetly through the nose—a pretty sight.

(On such occasions, by the way, it is advisable to leave a note on the hall table for the daily help, apprising her of what has transpired; as otherwise, in her early-morning zeal, she may unthinkingly restore the party-wall to its original position, thereby causing the bed to fly up, pin its inmate against the wall, and flatten him/her to the semblance of a bath-mat—than which there is no experience more harmful to the nerve-centres.)

Mention of bath-mats (my own preference, I may say, is for those having the word "BATH" worked on them in gaily coloured wools, as this prevents their being mistaken for egg-cosies or parachutes) reminds me that those flat-dwellers who are opposed to the Dibedroom on political or moral grounds will find the Babedroom (Bäbèdroom) an efficient substitute.

The British building industry having at last realized that citizens of taste and refinement like to

The Combined Bath and Bedroom

wash all over once a week, a bathroom can now be found in almost every flat. A moment's thought and a keen glance at the accompanying diagram will show that it is a simple matter to superimpose the spare bed on the bath in such a way that it—the bed, with or without tenant—can be hoisted above the splash-line while ablutions are in progress. There are, I believe, certain niggards who maintain that one can achieve the same end by merely fitting a lid to the bath and making the bed on the lid, which can also be used for

23

ping-pong, informal luncheons, etc.; but this seems to me a pinchpenny and anti-social practice, unworthy of a true host.

(In this connection, may I draw the attention of all to the Robinson Sunk Bath for Rather Sensitive Bathers? Housed beneath the floor-boards, and fitted with a neat and becoming trap-door for the head, this ingenious gadget should prove a veritable boon to self-conscious flat-dwellers who are subject to sudden visits by vicars, duns, rent-collectors, and the like. Prices on application.)

The idea of suspending furniture from the ceiling by a cunning arrangement of ropes and pulleys is so obviously practical—inasmuch as the largest room is always emptier at the top than at the bottom—that I cannot imagine why it has never been thought of before. The unchummiest flat-dweller must occasionally wish to throw a party, only to be deterred by the knowledge that if more than four people of normal dimensions are invited, two of them at least will have to spend the evening on the

The Sunk Bath

Economy of Space in the Lounge Hall

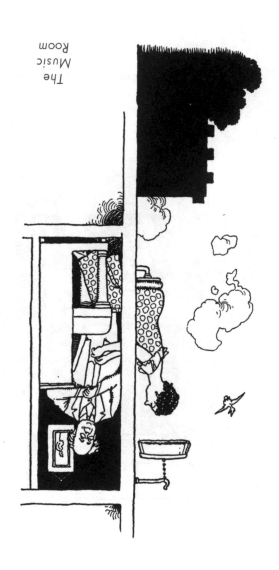

The
Music
Room

Dispensing with the Mantelshelf

stairs, feeling slightly disgruntled and much plagued by draughts.

By the use of hoistable furniture all such awkwardnesses can be avoided. A settee is not necessarily less comfortable because it is suspended from the ceiling; many, indeed, aver that the resultant swaying motion is extremely soothing and conducive to beautiful thoughts.

Aged aunts of a testy and critical disposition lose much of their power for evil when elevated in this way above the common herd; while everybody who has ever yearned to sit on the mantelshelf should give thanks for the hoistable dinner-table (see diagram), which not only encourages him to indulge that caprice but allows him to peck a bit while doing so.

A Convenient Little Morning Room for Breakfast

(It is essential, of course, that the ropes employed for these purposes should be of the stoutest hemp, as experiments have shown that the effect of a well-filled arm-chair abruptly falling from a height upon a defenceless skull is nothing to laugh—or even to smile whimsically—about.)

The chief merit of hoistable furniture, then, is that it enables the flat-dweller to sky—in a purely Academic sense—his surplus guests; and the same principle can be applied to nearly all those inanimate objects which, though indispensable to the Home, tend to lie about the place and trap the unwary foot. Coal-scuttles, small babies, kettles, old boots, cases of beer,

28

old umbrella-stands, large babies, card-tables, more cases of beer, spare clothing, medicine-chests, stuffed cats—all such bric-a-brac not only can, but should, be hung from the ceiling and lowered as and when required. A waggon hitched to a star is commonly supposed (for some reason I have never been able to grasp) to be a better and a nobler waggon than one which is hauled by a mule; and a coal-scuttle hitched to the roof-tree is far less obstructive than one which encumbers the hearth. C.O.D., or whatever it is.

I could enlarge upon this theme for several hours, to the irritation of all; but to do so would be to insult Mr. Heath Robinson, whose drawings, for the most part, are as self-explanatory as an unsuccessful actress. I would, however, particularly commend to notice his design—registered at Fishmongers' Hall, I understand, as first-class thinking-matter—for a

One of the Drawbacks of a Common Bathroom

The Garage

vertical space-saving garage, which seems to me to combine great purity of tone with a rare *diablerie* and a *soupçon* of *je-ne-sais-quoi*. Also his Communal Fireplace, by means of which four rooms can be simultaneously warmed at one-fourth of the usual cost—an economy which should help to console the flat-owner when the inevitable quarrels break out between Great-Uncle Alaric (in bed), who wants no fire at all, and Mrs. Gulping (in the kitchen), who wants a big one. Also his natty one-piece Sculleryette, which

The Extending Garage for Cars of All Sizes

The Sculleryette

proves that even an ancestor who was torn apart at Tyburn for throwing a currant bun at Nell Gwyn may subsequently have his uses.

The foregoing should suffice, I think, to convince the boneheadedest flat-dweller that there is plenty of room in the smallest home for the most unexpected things, provided the intelligence—if any—of all concerned is brought to bear on the matter.

Bedroom Space Economy

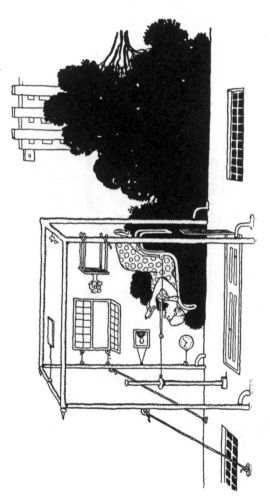

The Fresh Air Parlour

Modern Dressing-Room Furniture

FURNITURE AND FITTINGS

There is a well-known saying, attributed by some to Confucius and by others to the anonymous genius who composed the by-laws of Battersea Park, to the effect that a flat without furniture is like sage without onions, to without fro, or Snelgrove without Marshall—inconceivable, in other words. And the task of outfitting his new home with the essential bits and pieces is the first that confronts the novice flat-dweller when he has finally signed the lease, bought a kitten, and notified his change of address to all except his creditors.

In his innocence, it may be, he will hope to economize by using the various furnishings, fashioned of the stoutest mahogany and weighing approximately fifteen hundredweight apiece, which have been in his family ever since his Great-Great-Aunt Hephzibah eloped with a Heavy Dragoon, and which have

35

descended to him in the normal course of events. If so, the poor sap will be swiftly undeceived.

Our forefathers, failing to foresee that the typical British home was destined to shrink like blazes, went in for furniture in a big way, being particularly keen on beds somewhat smaller than a tennis-court and wardrobes large enough to accommodate the entire Committee Of Inquiry Into The Prevalence Of Left-Handed Teetotallers In the Die-Sinking Industry. Unless, therefore, he has the flat built round them——an expensive business, and savouring of ostentation——such heirlooms are about as useful to the modern flatholder as an acute attack of lumbago, and he would be well advised to get rid of them as best he may——say by dropping them into the Serpentine in the small hours of a moonless night.

Nowadays, furniture——as the above preamble was intended to convey to the quick-witted reader——is smaller than it used to be, and surprisingly different in shape. The present-day easy-chair, for example, makes its Victorian fore-runner look like a penitent's stool. If anything, indeed, it is a shade *too* easy, so that sitters of a full habit are apt to find, when once they have yielded themselves to its embrace, that they cannot get out again without a rather undignified struggle which imposes a grave strain on the braces.

To meet this difficulty the Robinson Chair-Emptier has been designed, tested, and patented all over. Its most important feature (see diagram) is a stout rope or hawser, one end being attached to the back of the chair, and the other to a small but powerful capstan in the kitchen. Should the occupant of the chair be called suddenly to the telephone or informed that fire has broken out in the bedroom, he or she has only to press

36

*A Little Mechanical Help in Rising Gracefully From a
Lounge Chair*

the bell communicating with the kitchen; whereupon
the menial on duty leaps to the capstan and does her
stuff, thus causing the chair-back to revolve and punt
the occupant gently but irresistibly into an upright
position. Pretty neat, we think.

Chaste Designs in Chromium

The discovery that chromium-steel tubing can be contorted into improbable shapes and unloaded on the public in the guise of chairs and tables has revolutionized the furniture industry and the Englishman's home. Whereas formerly the best furniture was made by carpenters, cabinet-makers, and similar skilled craftsmen (notable examples being Sheraton, who invented the Chippendale chair, and Hepplewhite, who designed Elizabethan umbrella-stands), nowadays the trade is almost entirely in the hands of plumbers, riveters, blow-pipers, and metal-workers of all sorts.

Chromium Comfort

As a result, the ultra-modern living-room resembles a cross between an operating-theatre, a dipsomaniac's nightmare, and a new kind of knitting.

The advantages of steel furniture, of course, are that it

38

Furniture Made to Measure

does not harbour worms, requires only an occasional touch of metal-polish, and can be bent into all manner of laughable designs. (Care should be taken, however, that only the best quality steel is used throughout, as there is no quicker way of annoying a portly and affluent uncle than by seating him in a chair which instantly buckles under him and hurls him to the floor, causing painful abrasions.)

It is quite possible, as the illustration makes plain, to construct a chromium-steel dining-room suite in one continuous piece—that is, without lifting the pen from the paper. This can be moved bodily from room to

The Chromium Shaving Chair

The One-Piece Chromium Steel Dining Suite

room—and even set up on the roof, in the event of anybody wishing to dine there—in about one-third of the time needed to shift an old-fashioned mahogany suite.

Moreover, when the conversation at the dinner-table flags and all present are wondering what the dickens to say next, the host can create a diversion by inviting his guests to guess where the suite begins and ends, and awarding a small prize, such as a book of stamps or an unopened tin of peaches, to the winner.

As a matter of fact, one can have any amount of clean, wholesome fun with a set of all-steel furniture.

FURNITURE AND FITTINGS

As the tubage or pipery employed is even hollower than a politician's promise, it can be made to earn its keep in any one of several ways. Thus, an all-steel chair, filled with water and maintained at the desired heat by a small oil-stove attached to the back, is what sufferers from influenza have been seeking for years without knowing it.

(Beginners, by the way, are advised to test the chair's temperature carefully before entrusting valued old relations to its charge. An octogenarian aunt who has been scorched simultaneously in eleven places is never quite the same thereafter, poor old soul!)

Wine-bibbers of a lethargic temperament can adapt the same idea to their own—and slightly baser—ends. By fitting small chromium taps to his furniture and

The Influenza Chair

An Interesting Development in Tubular Steel Furniture

connecting it by flexible pipes to the ale-vats in the basement, the three-bottle man can enjoy a continuous binge without ever moving from his chair. As many an over-enthusiastic toper has perished of a broken neck, contracted through stumbling on the cellar stairs while

The All-Steel Piano

fetching another quart, this innovation should have a beneficial effect upon the nation's death-rate,

Persons who do not bib wine, believing that it rots the boots and turns blue litmus pink, will find that this system—"remote-cask-control", as Mr. Heath Robinson calls it smilingly—works equally well, though less invigoratingly, with barley-water, cold tea, or lemonade. Neither porridge, however (which tends to clog the pipes), nor castor-oil (which erodes them) is suitable for transportation from keg to consumer by this method.

Before leaving the subject of steel furniture, I should like—in fact, I am absolutely determined—to draw the attention of the musically-minded to the all-steel piano, which is yet another child of Mr. Heath Robinson's prize-winning imagination. The drawback to an ordinary or gumwood piano is that it accords ill

with chromium sofas and is, moreover, liable to have feet put through it by furniture-removers who are anxious to get away before closing-time.

The all-steel or ironclad piano, on the other hand, is almost indestructible, and can even be slightly bombed with impunity, should civil war break out or an irascible neighbour wish to register a protest against little Daphne's nightly practice-hour; while the fact that it will not fall apart even when performed on by a female hockey-international is another point in its favour. Owing to the sleigh-like design of its base, the ironclad piano can also be hauled across frozen wastes by dog-teams, should that necessity arise.

(Speaking of pianos, I doubt if it is generally realized that an ordinary upright can be adapted for use as an emergency dresser and a repository for the spare crockery, pots of home-made jam, pieces of cold fish, and other jetsam which accumulates in the most orderly household. Before playing Tschaikovsky's "1812", however, all perishable foodstuffs and Venetian glass should be removed to a safer place.)

The use of steel piping for table-legs is not the only feature of modern furnishing that would have evoked whinnies of surprise from our grandparents. Equally noteworthy is the tendency to combine things, so that nearly every article of furniture is something else as well. Typical examples are the couch-with-bookcase-at-each-end, the twin-beds-with-cupboard-between, the chest-of-drawers-cum-wardrobe, and so forth. As Mr. Heath Robinson has been quick to perceive, this idea can be extended almost indefinitely; hence his design—illustrated herewith—for a combined

The Dresser-Piano

Modernity In Bedroom Furniture

bed-wardrobe-cradle-bed-dressing-table-chest-of-drawers.

It is hard to say precisely what purpose is served by joining everything together in this fashion; but there is no doubt that those who like this kind of thing will find it just the kind of thing they like. The reason for parking the baby on the wardrobe is, obviously, that if it gets dislodged during the night by a sudden breeze or bout of hiccups, it will probably fall on one of its parents and escape with minor bruises.

More interesting, in the opinion of many leading merchant princes, is the Combination Bathdesk, or Deskbath. In this age of hustle, time is money—though not much—and the keen business man is inclined to hurry through his weekly bath for fear of missing something good on 'Change. But with the aid of the

The Combination Bath and Writing Desk for Business Men

The "Nucrachair"

Deskbath, or Bathdesk (which can be had in steamproof teak, damp-resisting walnut, or just ordinary wood) the busiest financier that ever robbed an orphan of its birth-right can wash his neck with one hand and corner gumboots with the other.

One might say, indeed, that the De Luxe model, complete with telephone, soap-dish, reading-lamp, towel-rail, wastepaper-basket, solid rubber plug, and shelves for books of reference, is indispensable to those who, while appreciating that cleanliness is next to godliness, are never really happy unless planning a merger, underwriting a contango, or floating a company for the extraction of synthetic ambergris from clam-shells.

Oddly enough—as Karl Marx, I believe, was one of the first to point out—many successful business men are very fond of nuts. These will find the Robinson "Nucrachair" remarkably cheap at the price, as it will uncomplainingly crack nuts for them until further orders and leave their hands free for gesticulation,

fisticuffs, pocket-picking, champagne-drinking, and similar commercial pursuits.

Rather than let the business men have it all their own way, Mr. Heath Robinson has designed—rather deftly, as I think—a combined chair-and-breakfast-table suitable for any bachelor, whether a captain of industry or reasonably honest. There is no more pathetic figure than the man who—because he is facially unfortunate or financially unsound—has nobody to face him across the breakfast-table in a becoming *négligé*; and any attempt to brighten his lot deserves our cordial support. The Robinson chair-table is so constructed that, even if its occupant had anybody to face him across it, she would be unable to do so without barking her shins rather badly. Thus there is nothing to remind

*The Bachelor Combined Chair and
Breakfast Table*

the lonely breakfaster of What Might Have Been, and he can concentrate on his rusks and cocoa with an untroubled mind. And, as Roger Blenkynsoppe, the mediaeval poet, puts it:

> *Whenne worries doe come,*
> *Comes ye payne inne ye tumme.*
> *Whenne ye mynde isse atte reste,*
> *Thenne a manne mays dygeste.*

The connecting link between breakfast and carpets is, of course, crumbs. Not that it matters, except that I wish to draw attention to the Robinson Games-Rug, dedicated to chess-addicts, draughts-fiends and people who play halma, for some reason. Ultra-modern carpets can be pretty terrible; many, in fact, appear to have been designed by colour-blind Surrealists under the influence of some potent drug, such as gear-oil. A vote of thanks, therefore, is due to Mr. Heath Robinson for demonstrating that a certain amount of quiet fun can be extracted even from the last word in geometrical carpetry. Carpet-draughts, they tell me, is just the thing for the long winter evenings, and—as it can be played sitting down—will keep the old folks happy and amused while the young people are out at the movies.

One last but not unimportant point. In modern flats there is usually a marked scarcity of mantelpieces which have unaccountably gone out of fashion. This means that the flatholder has nowhere to put his feet when he totters home at eventide from the busy marts of trade and sinks exhausted into his arm-chair. It means also that he has nothing to lean against when laying down the law about this or that, expounding Venezuela's

Modern Carpet Designs may Provide Endless
Entertainment for your Friends

foreign policy, or telling his bored but resigned family how he put the Managing-Director through the hoop.

Has it ever occurred to such sufferers to fit little plush-covered foot-and-elbow-rests to their sitting-room walls? No, I'll bet it hasn't; yet these fittings are not only quite inexpensive, but add a note of distinction to any room and can be used, when not occupied by portions of the breadwinner, for drying socks or supporting small pots of geraniums.

If there is any aspect of flat-furnishing which has not been touched upon in this chapter, I shall be astonished to hear of it. Mr. Heath Robinson and I, it seems to me, have covered the ground as thoroughly as ground can possibly be covered by two middle-aged gentlemen of sedentary habits.

Don't thank us, however. It's a pleasure.

Disadvantage of Poor Steel

The Aquarium Work-Table

PETS AND PETS' CORNERS

The British, as is well known, are an animal-loving race. Let any smallish animal appear on any British cinema screen, and the concerted moan of, "Oo! Isn't he sw-e-e-t!" which instantly arises from the audience is audible in the next parish. There is no prettier sight, in my opinion, than a stout British stockbroker pausing in the middle of a wild contango to pat a passing fatten, while a British average-adjuster lamenting the faithlessness of a horse on which he has staked his last shirt is a spectacle to move the toughest to compassion.

Any creature of the wild, in short, can rely upon a cordial welcome and an occasional lump of sugar from the inhabitants of these islands (unless he happens to be a fox, a grouse, a rabbit, a pheasant, a trout, a grey squirrel, a stag, a salmon, or a caper-cailzie: in which case his luck is out).

It follows, then, that the British are a nation of pet-keepers. It is not too much to say—and if it were, I should say it just the same, being in a devilish mood—that there is never a moment of any day when a pet of one kind or another is not being kept somewhere in the United Kingdom.

The British pet-keeper, moreover, is catholic in his tastes; anything from a herd of Alderneys to a pedigree tadpole is good enough for him. Ordinarily he confines his attention—partly for reasons of economy, and partly because there *is* usually a clause in his lease forbidding him to keep anything exotic, such as wombats—to the simpler forms of livestock, lavishing his affection on dogs, cats, mottled Andalu-sian guinea-pigs, and similar fauna rather than on snakes, salamanders, and swampwarblers (large greenish animals, resembling a cross between an okapi and an asthmatic beadle, and found chiefly in Siam. Not that it matters).

The growth of the flat-dwelling habit has seriously inconvenienced Britain's pet-lovers. In the good old days, when every house stood in its own grounds and it was possible to pay one's income-tax without pawning the family plate, one could keep any amount of tame beasts about the place without tripping over them or getting complained about by neighbours. In that halcyon era, in fact, it was no rare thing for the breadwinner to support, in addition to his immediate family and a few derelict aunts, a mixed gaggle of rabbits, dogs, cats, horses, gold-fish, silk-worms, and canaries, with possibly a bowl of newts and a fowl or two thrown in for good measure.

It is no longer possible, unfortunately, to pet-keep

*Pets'
Playground,
Tryplit
Mansions*

A New Musical Chair

on so generous a scale. Love, however, will always find a way, and the enthusiast who cares to work it out with the help of the accompanying diagrams will discover that he can still enjoy, to a limited extent, the society of dumb friends. (Even dumber friends, I mean, than those who call in the ordinary way.)

There is no flat, for example, too small to accommodate a cat. (Which reminds me that in my earlier reference to cat-swinging I omitted to mention that there is a machine—invented by Mr. Heath Robinson, but not yet placed on the market—which enables the keen cat-swinger to enjoy his hobby even in the smallest flat. This gadget is so designed that the

arc of the cat-swing can be regulated to fit any room, so that the operator can put all his energies into his task at no risk of dashing the animal's brains out against the wall. It may be true, as some insist, that mechanically-swung cats have less entertainment-value than the old-fashioned hand-swung type; but then, one cannot have everything, can one?)

Even those who do not like cats—nor need the hot blush of shame suffuse their cheeks on that account, because Dr. Johnson and Lord Nelson couldn't abide the brutes, either—should not despair of finding a congenial and flatworthy pet. Certain animals, obviously, are temperamentally unsuited to flat life, these including:

Mastiffs. Deer. Seals. Peacocks.

Apes (at any rate, the larger species which are almost indistinguishable from Inspectors of Taxes. Little ones—about so big—*can* be kept in flats, but only at owners' risk.)

One may lay it down as a rough working rule, in fact, that any animal measuring more than one yard in any direction is out of place in a flat. The following simple verse, the author of which prefers, naturally, to remain anonymous, may prove helpful to beginners:

> In a flat, to avoid harmful scandal,
> Never keep a large mammal or psrwandl.*
> It's not what they eat,
> But the size of their feet
> That makes them so awkward to handle.

(* An obsolete Armenian word, meaning "anything bigger than a small calf or ＊rge jackal.")

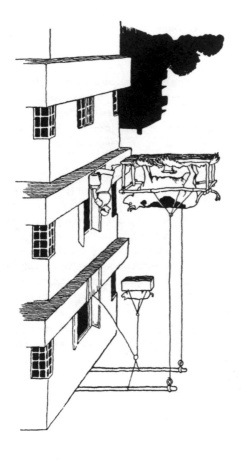

Some Flat Dwellers Manage To Keep A Cow

*A Handsome Tudor Overmantel with Chicken-Run
in Plantagenet Court, W.*

(Admittedly, it is possible—as one of our illustrations shows—for a flat-dwelling milk-addict to maintain a prize cow; but such goings-on are apt to cause a good deal of gossip locally and get one eyed askance by the police.)

On the other hand, fowls—the most satisfactory of pets, inasmuch as they not only gratify the eye but yield health-giving eggs, rich in vitamins and what not— ᵇake admirable flat-pets. An overmantel in the form

The Parrot Chair

of a small chicken-run (or vice versa) lends distinction to the meanest sitting-room, gives visitors something to exclaim about, and ensures that no guest need ever go hungry away, no matter how empty the larder.

The same principle can be applied, at a very reasonable cost, to rabbits, parrots, young babies, and other pets which do not wish to run about a lot, (I include babies in this category because they are— very properly—treated as pets in the majority of households and cannot honestly be regarded as human below the age of two.)

One advantage of modern furniture is that there i plenty of room for small animals beneath it—thou it was left to Mr, Heath Robinson to exploit

self-evident fact. Consequently a little wire-netting (obtainable at any reputable ironmonger's) is all that is needed to convert, say, a chair into a neat rabbit-hutch or parrot-cage. Thus the jaded flat-dweller, taking his ease at the day's end, can exchange chit-chat with his parrot and/or feed his rabbits without moving from his seat—a great blessing in this exhausting age.

Re babies: a good parking-place for these is the top of a grandfather clock. There, remote from the hubbub of family life and safe from the all-engulfing maw of the vacuum-cleaner (no respecter of persons, and as quick to swallow a stray baby as a casual tea-leaf), the infant can snore the long hours away

Modern Furniture Lends Itself Admirably
to Keeping Pets

in security and comfort, heedless of the flight of Time and the fluctuations of the Bank Rate. Unusually restless kids, of course, should be lashed in then-lofty eyrie with stout twine, lest they fall on the head of some unsuspecting visitor and get dented.

In flatholds where the head of the family (as distinct from the mere breadwinner) is an inveterate Spring Cleaner and resents having to shift a flock of fowls or a clutch of rabbits whenever she wants to beat the carpet, alternative accommodation for the livestock can generally be arranged outside the flat proper. (Tenants of flats improper seldom keep pets, for some reason.)

A well-made rabbitarium—which differs from an aquarium in that it contains no goldfish, thank goodness—looks well on any window-sill and is economically more useful than the old-style window-box. Pets and babie

Baby's New Safety Swing, for Flats Without Nurseries

Pets' Corner, Boldersbury Court, S.W.

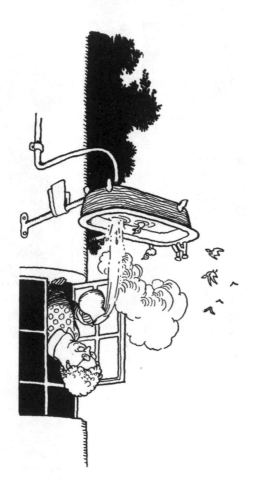

A Pretty Little Bird Bath
at Linnet Court

can also be suspended in cages and cradles (*en plein air*, as the French say, knowing the language) from stanchions attached to the exterior wall of the building; this keeps them out of sight when irascible old relatives drop in, and encourages balmy zephyrs to play on them in a very healing way. In such cases, however, it is advisable to rig a strong net as shown in the appropriate diagram, as nothing annoys a sensitive pedestrian more than to be knocked unconscious by a falling rabbit—or a falling baby, for that matter. The rabbits don't like it much, either.

As any house-agent will attest, many an excellent flat has remained unlet for years owing to its lack of a bird-bath. "What! No bird-bath?" prospective tenants exclaim, more in sorrow than in anger. "Tst! Tst! Then we must go elsewhere." And elsewhere they go, leaving the house-agent gibbering quietly to himself.

The Robinson (External) Bird-bath, here illustrated, solves *that* little difficulty. Fitted with h & c and attached to an outside wall, this decorative fixture will help the flat-dweller to win the gratitude of every thrush within a five-mile radius and enable him to devote his Saturday evenings to the study of bird-life in the raw. These fitments are (or should be) obtainable in two sizes—one for eagles, buzzards, turkeys, and other outsize fowl; and one for sparrows, nutchats, piefinches, etc.

Well, that, I think, is about all that can usefully be said on this subject. One cannot, obviously, mention every variety of pet likely to appeal to flat-dwellers; some people, for example, go in for lizards, though I never quite know why. I have said enough, however, to show that one need not necessarily go through life

alone and petless merely because one inhabits a flat. If all else fails, I mean to say, why not a nice canary? Or a nice dormouse, if you prefer them? It is all one to me.

Out of Danger

Roof Croquet

SPORT AND SOCIAL AMENITIES

There is, or should be, an old Welsh proverb, *Cwm bwllch llanfestiniogywm*, which means, approximately, that all work and no play makes Jack a dull boy. And what applies to Jack—whoever he may be—applies equally to Mr. Simpson, as many a flat-dweller is called. In other words, the man who does not occasionally relax and make a little whoopee is liable to crack under the strain of modern life and end his days forlornly in a mental home, believing himself to be the elder Pitt and/or the Queen of the May.

The British, being a nation of sportsmen—which means that they think nothing of wagering a shilling on a horse, the little rogues!—prefer to relax vigorously, usually with the help of a small ball which they can hit,

kick, or throw in all directions, thus keeping obesity at bay and doing their livers a bit of good.

It is a mistake to suppose, as many do, that recreation of that kind is impossible to the flat-dweller, or that the latter necessarily leads a more cramped and restricted life than the tenant of a ranch in Wyoming. Naturally, there are certain hobbies—notably horse-breaking and quail-shooting—which are more easily pursued on a ranch than in a flat; but the flat-dweller who gives his mind to it will find that he can get all the exercise he needs without stirring from the premises and messuage.

Golf, for example. In order to enjoy this king of sports (or this idiotic game, if you feel that way about it) the tenant of a modern flat need travel no farther than the roof. Nowadays flat roofs are all the rage, for some reason, and the larger the block of flats, the bigger the roof-space, as Euclid could undoubtedly have proved if he had thought of it. Roof-golf—or "roolf", as it is technically termed—differs from the ordinary variety in being infinitely more exciting. In ordinary or sea-level golf the worst that can befall the player is an apoplectic seizure (as when the vocabulary proves unequal to the strain), a peck from a passing viper, or a sharp blow on the sconce from somebody's misdirected chip-shot.

Roof-golf, however—combining as it does the best features of mountaineering, jugglery, and wire-walking—calls for a high degree of skill, a good head for heights, and a pretty tough constitution, as weak-lings soon succumb to exhaustion in the rarefied atmosphere of those lofty altitudes. (Incidentally, tenants of flats which are golfed on to any extent would be well advised to fit Triplex windows to their

A Round of Golf at
Dorisdene Mansions

Roof Hiking in a Modern Flat

living-rooms, as there is nothing so disconcerting to a conscientious diner as to be knocked senseless into the *soufflé* by a foozled mashie-shot.)

As with golf, so with hiking—which is the art or science of going for a walk rather more ostentatiously than our forefathers thought necessary. A moment's reflection will show that one can hike just as thoroughly on a flat roof as in the Kalahari Desert, and at a far more reasonable cost. The roof-hiker, moreover, has this added consolation—that when overcome by general lassitude, corns on the soles of

his feet, or a sense of the sheer futility of Life, he is spared that irksome journey home which has been so aptly described as the end of an imperfect day. All he has to do is to open the nearest trapdoor and pop downstairs, shouting for his slippers.

But what (it may be asked) about flat-dwellers of sedentary habits—those who, while opposed to violent exercise on moral grounds or by reason of their fallen arches, yet crave a little relaxation now

Communal Darts at Cyrildene Close

Sun-Bathing for Flat-Dwellers

and then? Are such poor souls to have *no* fun and games?

On the contrary, they may have as much or as little as they please. Are they, for example, piscatorially minded? Is it their delight to sit for hours in a state of suspended animation, dangling an impaled and indignant worm into an unresponsive piece of water?

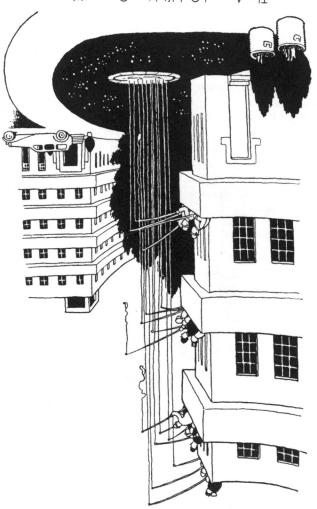

The Annual Goldfishing Competition

Keeping Obesity at Bay

Do they, in short, fish? Then let them consider the possibilities afforded by the ornamental pond which figures prominently in the forecourt of every ultra-modern Mansion, and into which belated tenants are ever liable to plunge when they return, singing slightly, from regimental dinners, nights out with the boys, etc.

Such ponds are easily stocked with gold-fish, which can then be fished for from the surrounding balconies. Thus the keen angler can enjoy his favourite pastime, and possibly contribute a little something to the larder, without even putting on his boots. In flats where the majority of the inmates are fish-conscious, angling competitions—as staged so frequently on seaside piers, for some reason that escapes me at the moment—can readily be arranged, a good time

being had by all. Aye, and by the gold-fish too, for even a henna-tinted sardine must occasionally tire of wambling round and round a pond, with no excitement other than the bi-weekly ant's-egg.

Flat-dwellers who are biased against gold-fish—whose resemblance to eminent politicians does undoubtedly repel the sensitive—can substitute carp, or perch, or even whitebait. Anything larger than a cod, however, or less edible than a halibut, is obviously ineligible.

A Neat Dealing Gadget for Bridge Parties

Nor is this the only use to which the modern flat-balcony—not to be confused with a balcony-flat, which is an entirely different thing—can be put by an intelligent tenant. In the old days, the average balcony was a flimsy, open-work affair of hopelessly overwrought iron, capable only of sustaining those little old aunts and potted fuchsias which accumulate in the most orderly households. The modern balcony is quite another matter, being fashioned usually of the best concrete and strong enough to support three Aldermen or a county cricket XI. When filled with water—obtainable at a moderate cost from any reliable tap—it forms an admirable bathing-pool, in which the local residents can frolic with happy cries, uninhibited by the glacial glances of Beach Inspectors.

(As the illustrations show, balcony-bathing is eminently suitable for persons of mature years, globular design, and indifferent swimming powers, as they run no risk of being swept away by the current—to the ill-concealed delight of their heirs and assigns—or otherwise withdrawn from circulation.)

No mention of balconies would be complete without a reference to the Robinson Synthetic Outlook, or Artificial Horizon. This remarkable device (see diagram) is designed for the benefit of flatholders whose windows command extensive views, but of the wrong kind. Gasometers, power-stations, factory chimneys, and municipal garbage-dumps play a vital part in the nation's daily life; but as things to gaze at daily from a drawing-room window they compare unfavourably with the Taj Mahal, the mountains of Mourne, Niagara, and Lake Como.

Holiday Joys in Modern Flats

An Artistic Way of Hiding an Unsightly View

SPORT AND SOCIAL AMENITIES

Hence the Synthetic Outlook—which, incidentally, is in the direct line of descent from the Hanging Gardens of Babylon. Briefly, it consists of a stout platform, attached to the exterior of the building on a level with the windows concerned. On this platform the flatdweller can erect a small portion of whatever landscape he prefers to look at in his hours of ease. With the help of a few potted shrubs, a *papier mâché* summer-house, and a brace of stuffed flamingoes one can contrive a dummy view that will evoke yelps of admiration from myopic visitors and give the local bird-life considerable food for thought—inasmuch as sparrows are poor judges of scenery and would just as soon lay their eggs on a Synthetic Outlook as elsewhere.

Chromium Cradle

*Bathroom
Space
Economy*

Converting to crazy

CONVERTED HOUSES

Notwithstanding the innumerable blocks of modern flats which are springing—or, to be strictly accurate, crawling—up all over the fair face of England and causing acute pain to the artistically minded, the Converted House is by no means obsolete. On the contrary, in London's inner suburbs—Hampstead, Streatham, and the like—converted houses are almost as numerous as those which have not yet seen the light.

Flats in converted houses are of two main types— the "Garbo", or self-contained; and the "Piccadilly", or more-or-less-open-to-the-public. In a self-contained flat one can lock the outer door, remove one's boots, and let the world go by; whereas in the other kind one can attain complete privacy only by hiding in a cupboard, inasmuch as—there being no outer

81

*A Neat Solution of the Vexed Question of the
Back Garden to a Converted House*

door—a considerable portion of the world goes by
through the hall.

Life in a converted house calls for a good deal of
give-and-take on the part of the inmates—particularly
in the matter of the garden, if any such there be.
Ordinarily the occupant of the lowest flat regards the
garden as his own, and is quick to repel with oaths and

even swanshot any attempt by his overhead neighbours to set foot therein. Too often this dog-in-the-manger attitude gives rise to bitter feuds and the exchange of coarse remarks, and may even result in the tenant of the basement being knocked sideways by a saucepan or other missile dropped from an upper window.

A simple solution of this grave social problem is illustrated here. The converted house, we will suppose, contains four flats, inhabited respectively by a quantity-surveyor, an importer of dolls'-eyes, a professional flautist, and a salesman of water-softeners, each with his family and other chattels. Under the existing system the flautist, as tenant of the lowest flat, could claim the sole use of the garden and aggravate the quantity-surveyor (such men being notorious umbrage-takers) to the verge of frenzy by practising "My Red-Hot Baby" in the shady corner by the dustbin on hot summer evenings.

Unpleasantness of that kind could easily be avoided by dividing the garden into four (4) equal parts, and allotting one part to each flat. Thus every inmate of the house would have a small piece of this earth, this realm, this England on which to perform his breathing-exercises, grow dandelions, keep a rabbit, play the flute, study bird-life, or do a little folding of the hands in sleep on Sunday afternoons.

In converted houses where a spirit of camaraderie prevails, and whose tenants dwell together in budgerigar-like amity, there is no need for so drastic a division of the messuage. Instead, communal cricket can be enjoyed by all whenever the elements permit, the back passage being regarded as part of the field for fast-bowling purposes, and the cost of the necessary window-repairs defrayed from a common

*Overcoming the Difficulty of Cleaning
the Outside of a Casement Window*

*Even in the Confined Garden of a Converted House
Communal Sport is Possible*

fund. As, however, there are few, if any, converted houses of that Utopian sort, it would be a waste of time to discuss this point in detail.

Since flats in converted houses were never intended to be flats, they are generally rich in drawbacks calculated to fray the tenants' nerves and make veins stand

out of their fore-heads. In many cases, for example, the original front door is deliberately cleft in twain, one half giving access to the ground floor, the other to the upper regions. For tenants of normal girth that is a satisfactory arrangement enough; but it is pretty galling for the outsize flatholder who, hurrying forth to attend a funeral or post a letter to his bookmaker, gets jammed in the exit and has to be cut loose with hacksaws.

To meet this difficulty the Robinson Adjustable Entrance has been invented, and is here shown. This is merely a movable

Adjustable Double Entrance

—to a Converted House

doorway, working on aluminium runners, which can be adjusted in the wink of an eye to fit anybody from an under-nourished jockey to an over-developed publican. In the unlikely event of two over-developed publicans wishing to enter or leave the premises simultaneously, one or other of them must curb his wanderlust and wait, with what patience he can muster, until the other (or the one) has got safely through and away.

In the kind of house that gets converted into flats there is, as a general rule, but one bathroom. The lessee of this refinement can sometimes be ca-

joled into sharing it with his less fortunate co-tenants, but more often the latter are forced to ablute as best they can in basins, disused pith-helmets, etc. To such poor baffled seekers after cleanliness I commend Mr. Heath Robinson's design for a converted scullery, in which the copper functions as the bath.

Although it is not everybody who can contort himself sufficiently to wash all over in a copper, a copper-bath has the advantage that it can be kept hot indefinitely, inasmuch as the fire is situated immediately beneath the bather, who has only to lean out from time to time and poke it. To flatholders who are both bathless and devoid of coppers I can only suggest that they should utilize the top of the front porch in the manner shown on page 80, using the interior end of the bath as a bridge-table when it is not required for washing, model yachtsmanship, or exercising the gold-fish. Alternatively, they can beg a quick bath of then-hostess when next they go out to dine, or hoard a piece of soap against the coming of their annual holidays.

Tenants of top-floor flats in converted houses will often find, while rootling about in an aimless sort of way on a wet summer afternoon, that between them and the roof is a commodious attic. Such attics, being deficient in head-room and lacking in windows, are normally occupied only by spiders, cisterns, and yards and yards of rather sinister lead-piping.

With a little thought, however, any attic can be made to play its part in the economic scheme. A small black-and-white artist, for example, can be housed in it—at the flatholder's risk, of course—and made to pay at least a pound a week for the accommodation.

Conversion of an Old-Fashioned Scullery
to a Bathroom

*An Attic Converted to a Flat Suitable for a
Black-and-White Artist*

(Several black-and-white artists earn rather more than that, and can be stung accordingly.) Or, by punching holes in the floor and installing in the room beneath a few specially adapted piano-stools, an attic can be converted into an attractive dining-room, suitable for any number of torsos. Steamer-trunks, when not needed on the voyage, can also be kept in attics, as can odd boots, broken banjos, and photographs of the flat-holder when young.

Above the attic, as hinted elsewhere, is the roof; and here the tenant, if he feels so inclined, can construct, with the help of a mattress or two and a few pots of old-maid's-ear, various little snuggeries or cosy-corners among the chimney-pots. As the roofs of converted houses, however, are seldom completely, or even slightly, flat, he would be well-advised to do no such thing if he is afflicted with a suicide-complex.

Section of a Converted House Showing Convenient Arrangement of Space Available for Lounge and Dining-Room

*A Snug Little Corner in the Roof Garden
of a Converted House*

A word, in conclusion, re crazy-paving, which is all
the rage this season among tenants of ground-floor
flats, or "garden-hoggers", as they are sometimes
termed. It is not generally known, I think, that to make
a crazy-pavement it is only necessary to strike an
ordinary pavement repeatedly with a hammer, Freud

tells us that the same treatment, if applied to a retired Major-General or a designer of water-wheels, will produce precisely the same effect.

An odd world, is it not?

Waiting for the Plumber to Deal with the Leak in the Linen Cupboard

Washing Day

Windows to Fit
all Figures

SERVICE FLATTERY

As all students of the world's history are aware, the service-flat is a comparatively recent growth. In the Victorian era, when Britain's manhood lurked behind an impressive zareba of whisker and the bustle was a prominent feature of the social scene, it was entirely unknown—as, incidentally, were pyjamas.

In that spacious and elegant age the British house-wife thought it no sin to do a little housework now and then. Housework, she would have urged in self-defence, was more or less what she was for; and her husband would cordially have agreed with her. Moreover—cocktail-parties being then in their infancy, the cinema merely a disturbing rumour, and

*Economical Arrangement of Bedroom Space
in a Converted House*

the BBC mercifully hidden in the future—house-work
helped to keep her busy and amused between Albert's
ceremonious departure for the City in the morning and
his ditto home-coming in the evening.

Not so today, by gum! In recent years, apparently,
the theory has developed that the modern English woman

is a kind of fragile moron, easy enough to look at, but incapable of boiling an egg, dusting a what-not, washing a moustache-cup, or climbing a flight of stairs. Hence the service-flat, which is guaranteed to do everything for its occupants except pay their rent and blow their noses. Indeed, when the tenants of a high-class service-flat have brushed their teeth, eaten their meals, and gone bankrupt, they have done about all they are allowed to do with their own fair hands. The time and energy thus saved they can—but seldom do—devote to good works, meditation, or the study of improving books.

The basic principle of service-flattery is that whatever the tenant needs must be instantly hurled at him (always providing, of course, he does not need a performing emu or a vat of Malvoisie), and what-ever he has ceased to need—e.g. old razor-blades—as

An Improved Dinner-Waggon

instantly swept away. As it happens, neither I nor Mr. Heath Robinson have ever set foot inside a service-flat (Well, what of it? We have never set foot inside Rhodesia, a sedan-chair, gaol, or diving-boots, if it comes to that), and consequently have no idea how, or even if, the system works. However, as between us we have enough imagination to ballast a small schooner, we have no hesitation in offering the following hints to those who—wishing to move with the times or having been dropped on their heads when young—desire to construct a service-flat for their own use.

It goes without saying that the first essential for a service-flat is a reliable lift—or "elevator", as it is laughingly called by Americans, with their passion for *le mot juste*. No lift—no service-flat: such is Nature's inexorable law, Nature having evidently realized that bounding up and down stairs is one of the things the present generation is not frightfully keen on, or even good at.

A lift, then, is a *sine qua non*—if that expression means what I sincerely hope it does. And here, it seems to me, there is room for considerable improvement. The lifts in a modern block of service-flats are admittedly things of beauty, upholstered in the richest plush, panelled in bird's-eye maple or some such modish stuff, and controlled by courtly myrmidons in buttons. It seems the more odd, therefore, that no entertainment is provided for the long-distance passengers. Having only income-tax and kindred ills to think about—and hardly anything to think *with*, in any case—the tenant of a tenth-floor service-flat is apt to find his lift-life unconscionably tedious.

Lift Comfort

Yet it would be a simple matter, surely, to equip every lift with a small cinema apparatus, so that the Tired Business Man could be regaled with a soothing little programme—say a news-reel, a refined comedy, and a short film dealing with the home-life of the Scandinavian puffin—during his long journey dinner-wards. The idea is so obvious that I cannot imagine why nobody has thought of it before; but if any of the flat-managers—or whatever they are called—who will probably think of it in the near future, remembers to reward me with a case of wine or a small donation, nobody will be more astonished than myself.

An important point about up-to-date service flattery is that almost everything, from clean towels to sardine-sandwiches, goes up and down in lifts of one kind or another. Where lifts of no kind are available, it is possible—as the illustrations show—to achieve the same effect by carving holes in each floor and installing a simple home-made "hoister", worked on the cog-wheel principle. Those whose means will not permit of this solution can get practically the same result by hiring a sufficiently slender minion to take the hoister's place.

Experiments conducted, regardless of expense, by Mr. Heath Robinson and the Board of Trade have shown that the cog-wheel method is unsuitable for conveying cooked foods to a great height, the inevitable vibration tending to jar the viands out of shape and annoy the customers. Nothing daunted, Mr. Heath Robinson has obligingly designed the Concertina Grub-Hoist, a worm's-eye view of which is appended. As its name implies, the C.G.-H. looks rather like a gargantuan concertina, and behaves more or less as such, the

Quick Service In Breakfast Parlourette

essential motive-power — or "air", to give it its full name — being supplied by a small hand-pump, situated in the kitchen, and operated by the cook, if he or she can be persuaded to do so. By this means the most temperamental delicacies, such as elderberry jelly with tomato sauce and models of the Eiffel Tower in granulated sugar, can be transported even to the attics with impunity.

In service-flats of the latest design, dustbins, I understand, are frowned upon. The tenant simply pushes his empty bottles, disused salmon-tins, irreparable old underwear, and other ullage through a hole in the wall, whence it whizzes down a chute to the eager dustman waiting in the basement. For buildings where this arrangement is architecturally impossible, the Robinson Rubbi-shifter is just what the doctor ordered.

Sending up a Mutton Chop in a Modern Service Flat

SERVICE FLATTERY

Frankly, this is just an ordinary dust-cart fitted with an adjustable maw resembling a new variety of ear-trumpet. At the glad summons of the Rubbishifter's bell, the flatwife has only to stagger to the window with her dustbin, decant it into the mouthpiece and return, humming a gay snatch of song, to her backgammon or knitting. The rubbish thus collected can either be packed in sacks and flung into the sea off the North Foreland, or carefully sorted and distributed to rural jumble-sales.

Conscience forbids me to leave the subject of service-flats without mentioning that extra-ordinarily useful little dingus, or what-is-it, the Robinson Skulltoaster. Ordinarily the draw-back to toast-making is the necessity of using at least one hand, which makes it

The Daily Dust Collection

Tea and Toast

impossible for the toaster to gesticulate, unpack parcels, or do Indian-club exercises simultaneously. The Skull-toaster, however, simplifies matters enormously. Obtainable in various sizes, fitting snugly to the dome, and adding not a little to the charm of the face beneath, this inexpensive doohickus should come as a Godsend indeed to the busy flatwife.

In conclusion, may I suggest a suitable motto for all intending builders, owners, and managing-directors of service-flats?

"Service, not self, and really constant hot water!"

The Smell of Scorching

The Dinner Gong

An Early Waterside Bungalow

BUNGALOID

At first sight it might appear that a dissertation on bungalows is out of place in a volume (destined, we trust, to become a standard work) dealing with the hazards and joys of flat life. A moment's thought, however—or two moments', in the case of those who have had a public-school education—will show that flats and bungalows (unlike water-voles and peacocks) have a great deal in common.

The general lay-out, for example, is the same for each—a small number of even smaller rooms, all on one floor, and so arranged that a person wishing to convey a dish of jellied eels from the kitchen to the dining-room must traverse the best bedroom, the hall, the worst bedroom, the lounge and the nursery *en route*,* Like flats, bungalows are seldom owned by the same family for countless generations.† Like bungalows,

* "Man wants but little bungalow . . ." † "Nor wants that little long."

107

flats seldom attain such an age that they can qualify as historical monuments. In the average bungalow, as in the average flat, a muffled oath uttered in the bathroom is clearly audible in the parlour, while in neither flats nor bungalows is it possible to maintain any pet larger than a smallish aardvark.

In other words, the only difference between flats and bungalows is that the latter—like a conscientious magistrate—are completely detached. (Indeed, having very little in the way of foundations, some bungalows are liable to become too completely detached by sudden tempests; but we will go into that later.) No excuse or apology, therefore, is needed for mentioning them here.

In England the majority of bungalows are situated (a) on the sea-coast or (b) on the banks of rivers, such as the well-known and justly popular Thames. Certain favourites of fortune own both a flat and a bungalow, using the one for entertaining people through whom they hope to obtain introductions to members of the Peerage, and the other for week-end relaxation; but it is with the bungalow as an all-the-year-round dwelling-place (or "Kozykot", as it is often—alas!—called) that we are chiefly concerned.

The rural bungalowner, like the urban flatholder, is apt at times to wish that he had just a little more room in which to exercise his authority. Most bungalows are pretty small, and seem even smaller when invaded by gay parties of acquaintances in search of a drink or a shake-down. As the illustrations show, however, this drawback can to some extent be overcome by the use of a little imagination, a furlong of stout twine, and a few hooks screwed into the ceiling. (Note, in this

Compact Arrangement of the Limited
Space in a Bungalow Dining-Room

A Bed Dining-Table for—

connection, the bed-dining-table, designed for the bungalowner who, by reason of profligacy in his youth or an ill-advised investment in a Russian rubber-mine, finds it necessary to take in paying-guests. Thanks to

—a Bachelor's Bed-Sitting-Room

The Extending Bungalow for Week-End Parties

this cunning little gadget, a lodger can now dine and hit the hay practically in one movement—an obvious saving in time and shoe-leather.)

To those who can afford the essential outlay I would strongly recommend the "Hero-Extengalow" (otherwise the Heath Robinson Extending Bungalow) —a veritable boon to those who are much visited

The Baby Grand in a Bungalow

An "Air Frais" Bungalow for Warm Weather

by exceptionally obese uncles or passing football teams. The chief feature of this device is a movable exterior wall, working telescopically and operated by a small winch on the roof. If it is thought desirable, this principle can be applied to all four walls of the building, so that on the approach of unexpected guests—say, a platoon of Territorials or the Ways and Means Committee of the L.C.C.—the bungalow can be expanded simultaneously in four directions, to the delight of all.

Somewhat similar in theory and design is the *Air Frais* (a French expression, meaning "draughts"). On hot summer nights—last year there were approximately four of these in England—when sleep tarries afar and the moon blazes pitilessly down from a cloudless sky,

The Sneeze

A Modern Bed-Sitting-Room

many an insomniac bungalowner must have wished that he could take the roof off. Well, now he can. Admirably simple in construction and worked by an inexpensive bedside winch, the liftable roof enables the tenant to enjoy all the benefits of sleeping in the open without any of the risks—for, as he remains technically indoors, he can neither be trodden on by casual kine or charged with trespass by malignant farmers.

While both the "Hero-Extengalow" and the *Air Frais* might be classified as luxuries, the Floating Bungalow is almost a necessity to those who, like the simple primrose, dwell by the river's brim. Owing to the eccentricities of the British climate, our rivers have a way of swelling suddenly, causing widespread

damage to crops and complicating life considerably for the local postmen. On such occasions the river-side bungalow, being fashioned of wood throughout and but lightly rooted in the soil, tends to come unstuck; and there is nothing so disconcerting to the head of a family as the discovery that his home, containing self and dear ones, has broken adrift during the night and is bowling briskly past the Nore in the teeth of a stiff sou'-wester.

(I speak with some feeling on this point, having recently lost a valuable old aunt in this way. Her bungalow—"*Mon Abri*"—which left its moorings at Datchet during the floods of 1935, was last sighted off the Azores in January of this year, travelling in the general direction of the West Indies and flying an inverted sealskin tippet as a signal of distress. A sad loss to us all.)

No such calamity, however, can befall the inmate of a Robinson Floating Bungalow. This is supported on telescopic pillars, and so can be raised to any desired height above the raging waters—a nasty snub for the river, incidentally. As an additional safeguard, genuine hogskin bladders are attached at intervals to the exterior of the building, these requiring only a little occasional bellowing to maintain them in good condition. Any fish found in the cellar when the flood subsides can be boiled, fried, or kept as pets, as the whim of the moment dictates.

Most of the above remarks apply equally to seaside bungalows, though these—the sea being commendably regular in its tidal habits—are less susceptible to inundation. Citizens who have hitherto been deterred from taking a seaside bungalow by the suspicion that they look pretty awful in a bathing-

*The Floating Bungalow, for Districts
Subject to Floods*

The "Modesty" Seaside Bungalow

suit—as a surprising number of citizens do, by the way
—will be interested in the "Modesty" bathing-
attachment here depicted.

The Bungalow Kitchenette

The Bungalow Bedroom

By means of this ingenious and not uncomely contraption, which can be obtained in various colours and erected in a few moments by two men and a small boy, the self-conscious bungalowner who bulges in

all the wrong places can (a) enter and (b) leave the water in the strictest privacy, untroubled by the pop-eyed gaze of the multitude and the jeers of the younger generation. For financiers, Members of Parliament, film-magnates, City aldermen, and others whose figures have gone haywire under the influence of rich foods and the limousine-habit, a "Modesty" should prove an acceptable Christmas gift.

That will be all about bungalows, I think. And if the foregoing suggestions fail to bring a little extra sunshine into the lives of Britain's bungalowners, I cannot see that it is any fault of mine.

Conversion of a Bathroom to a Smoking Lounge and Sculleryette

Handing up the Deoch an' Doris in a Modern Service Flat

The Draught Under the Door

THE DARKER SIDE OF FLAT LIFE

No conscientious monograph on flat life would be complete without a tactful reference to a few of its disadvantages. Nothing in this imperfect world is perfect—except asparagus and a certain pre-War whisky, now almost unobtainable. Every rose has its thorn, every income its tax; and he is an exceptional flatholder indeed who has never uttered a resounding oath and exclaimed peevishly, "Oh, why don't I live in a lighthouse?"

In fact, if any such flatholder exists, he should be acquired by the nation, stuffed, and presented to the Natural History Museum; for we shall not look upon his like again.

One of the main drawbacks to modern flat life is the thinness of the walls. Our forefathers, when they built a house, built it to withstand everything from white

Thin Walls

ants to enemy shell-fire. Walls less than three feet thick they considered almost as vulgar as walls more than three inches thick are considered today. As a result, it takes considerably longer to pull down one old house than to erect a block of twenty-seven new flats on its site. (There is probably a moral here somewhere, but we have no time to hunt for it now.)

Noises of all kinds, then, are peculiarly audible in flats—a source of some embarrassment to the sensitive tenant who likes a quiet life. There is nothing more irksome to a modest and retiring man than to be forced to overhear, through the party-wall, an embittered dispute between the couple next door about that red-haired girl at the tobacconist's, or some other intimate aspect of the marital state. On such occasions the only course is to stuff the ears with cotton-wool, thereby—very possibly—becoming deaf to the telephone and missing an invitation to dinner.

A Resilient and Noise-Proof Floor

Other people's piano-solos, too, are easily heard in flats, especially after 11 p.m. These, when deftly executed, fall quite pleasantly upon the ear and call for no protest other than a mild tap on the dividing

Economy of Space in the Morning Room

wall at the "end" of the second hour, or at the listener's bedtime, whichever arrives first. But when—as is almost invariably the case—the pianist appears to be playing in boxing-gloves, and with his or her head in a bag, the listener's natural impulse is to fly into a frenzy and belabour the wall with fire-irons. Well, he *can* do that, of course, but only at the risk of sending the fire-irons—a present from his nearest and dearest, very likely—clean through the wall.

126

The thinness of the modern wall is largely responsible, in my opinion, for the decline in popularity of pictures. Once upon a time no room was considered fully furnished without several steel-engravings, each some two yards square, depicting stags at bay, pairs of lovers having a refined dust-up, or adenoidal children remarking to large, woolly dogs: "Down, Doggie, down!" Nowadays, however, the mural decorations of the average flat include nothing heavier than a grocer's calendar, a snapshot of Aunt Bessie romping

The Warning Mirror for Lounge Users

Sane Precaution in a Period House

in the shallows at Bexhill, or a timetable of the local train-service.

For, after all, no man is anxious to drive nails into his walls when he knows that the sharp ends will probably emerge in the next flat, causing widespread consternation. A flatholder who is continually having ornaments pushed off his mantelpiece by his neighbour's picture-hanging efforts is apt to get rather fretful about it—though not so fretful as that friend of mine who happened actually to be leaning against the wall on which the man next door was trying to hang an oil-painting of Loch Lomond, and who sustained half an inch of cold steel in the back of his indignant neck.

Another drawback to the ultra-modern flat is the extreme smallness of the rooms, not only to and fro, but up and down. This makes life very difficult for tenants measuring more than seventy-three inches from keel to masthead, who are liable to get their proud heads knocked completely out of shape when rising suddenly from the dinner-table or springing from the chesterfield to grapple with a burglar.

For these sufferers the Robinson Head-Buffer, or Dome-Protector, has been deliberately designed. This —very useful also for those who live in delightfully quaint old cottages with genuine oak rafters and not a stitch of plumbing—is simply a leather pad, stuffed with

128

gulls' feathers and attached to the skull by a stout strap passing under the chin. Thus armoured, and looking only slightly rococo, the tallest tenant can play leapfrog in the dining-room with his favourite uncle, and remain quite unstunned by the ceiling.

In this age of hustle, when blocks of flats are not here today and fully occupied tomorrow, the detail work about the place is sometimes not too good. I know a flatholder, for example, who, failing to realize that new doors often warp under the influence of steam-heat, was imprisoned in the bathroom of his new flat for three days, thus missing a City banquet, a round of golf, tea with his Aunt Lavinia (who took offence and altered her will), and an appointment with his dentist.

The novice flat-dweller, therefore, should remember not to be too rough with the fixtures. When one is in a hurry, as one usually is about 9.45 p.m., to reach the "Archdeacon's Arms" before closing-time, there is nothing so provoking as a front door that comes away in the hand or stoutly refuses to open.

New taps, too, are very subject to washer-trouble—though this, as the illustration shows, can sometimes be ameliorated by old boots—and should be handled carefully, lest they come apart and inundate the premises.

As for draughts, these are just as prevalent in old-

Oak Beams

Weak Hinges

fashioned houses as in modern flats, and in any case retire baffled from the Robinson Antidraught Chair, in which the most delicate hypochondriac can sit snugly and un-chilled, even in the full blast of an equinoctial monsoon.

The fact that this about exhausts the list of drawbacks to flat life shows that, when all is said, flats are pretty easy things to live in. Home, in any case, is where the heart is, and the man whose heart is in a flat will obviously be unhappy in a caravan. As Milton puts it in his well-known "Lines to a Lady of Fashion on the Occasion of her First Visit to a Dentist:

THE DARKER SIDE OF FLAT LIFE

Be it ever so small, be it ever so humble,
You'll still hear me cry——or, more truthfully, mumble:
"If you'll buy me a ticket, why, just watch me roam!
But otherwise, frankly, there's no place like Home."

That about sums it up, I fancy.

The Washer-Trouble
Overcome

*Communal Eurhythmics and Physical
Jerks on Saturday Afternoons*

Taking a Flat Before Completion

TAILPIECE

It is not to be supposed that the reader (if any) has got as much fun out of digesting this book as Mr. Heath Robinson and I got out of making it. Still, we hope that his sufferings have not been entirely in vain, and that he now knows rather more about flat life, Its Cause And Cure, than he did when he first left school.

It only remains to add that every dingus, gadget, apparatus, and doohickus mentioned in this work has been personally tested by Mr. Heath Robinson and myself, with the following exceptions:

Communal Eurythmics (as we were unable to hire a balloon).

The Flat Wedding (as we are both married already).

The Last Collection (as the G.P.O. refused to lend us a postman).

*The Flat Without
a Balcony*

TAILPIECE

The Deckcheyrie For Unbalconied Flats (as we both weigh a good deal).

However, these will all be found to work perfectly, we shouldn't wonder. If not, we're sorry.

In conclusion, and not a moment too soon, we wish to extend to all who are connected in any way with fiats—i.e, flat-builders, flat-dwellers, flat-managers, flat-borrowers, people who let flats, people who design bell-pushes for flats, people who operate lifts in flats, people who deliver beer at flats, and even people who merely gawp at flats from the tops of passing trams—our best wishes for a very merry Christmas, an astoundingly happy New Year, a fearfully Jolly Easter, and a Simply Incredibly Glad-Making August Bank Holiday.

Fairer Than That, We Feel, We Cannot Say.

The Surveyor

The Last Collection